Wedding Dress
1740—1970

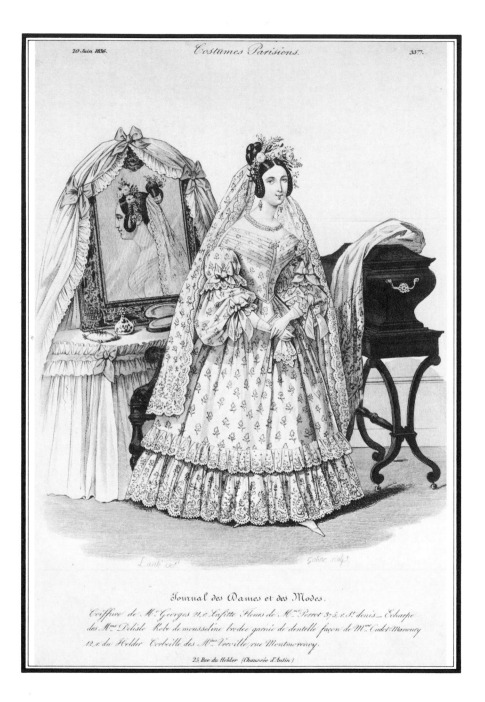

Journal des Dames et des Modes.

Coiffure de M*.* Georges 21.r. Lafitte Fleurs de M*me* Perret 375. r. S*.* denis — Echarpe
des M*rs* Delisle Robe de mousseline brodée garnie de dentelle façon de M*mes* Cudot-Manoury
12.r. du Helder Corbeille des M*mes* Verville rue Montmorency.

23 Rue du Helder (Chaussée d'Antin)

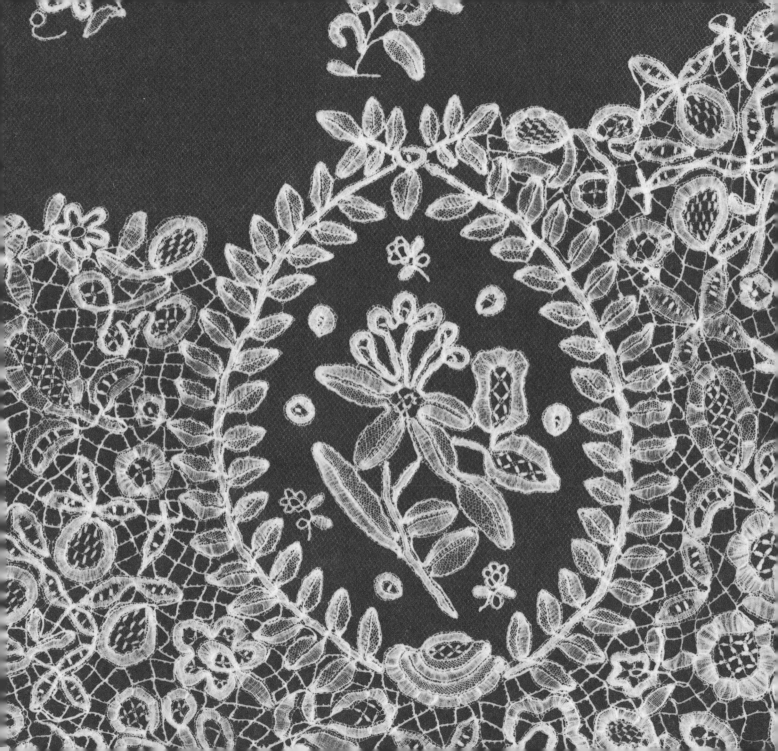

Victoria and Albert Museum

Wedding Dress
1740—1970

Madeleine Ginsburg

London: Her Majesty's Stationery Office

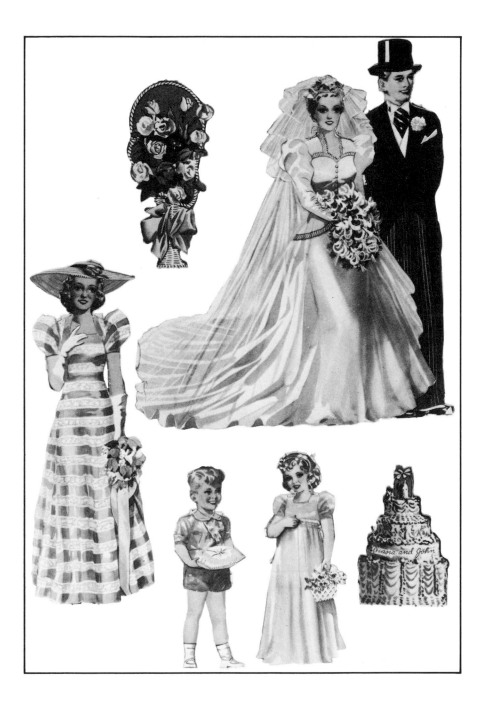

Acknowledgements

The museum gratefully acknowledges the generosity of all those who so kindly gave wedding dresses and accessories to the museum collection and responded to requests for additional information.

Despite the existence of useful secondary works, P Cunnington and C Lucas, Costume for Births Marriages and Deaths, London, 1972; A Montsarrat, And the Bride Wore . . . , London, 1973 and P Stevenson, Bridal Fashions, London, 1978; museum guides such as The Gallery of English Costume, Weddings (Wedding Costume 1735–1970), Picture Book Number 10; wedding clothes are still best researched from original sources. Personal reminiscences, memoirs, family photographs, fashion journals all provide useful information. Etiquette books set the subject in its social context and fashion history works into it costume sequence.

This book illustrates and comments on a selection only of the wedding dress collection of the Victoria and Albert Museum, of which a number are currently (1981) on display at the Bethnal Green Museum of Childhood.

My sincere thanks are due to Noreen Marshall and Ken Jackson for their patient assistance in the preparation of this book, and also to the Staff of the Bethnal Green Museum of Childhood, past and present, the Victoria and Albert Museum, Department of Costume and Textiles and members of the Photographic Studio. I would also like to thank Vere French, Susie Mayor, Christopher Lennox-Boyd and Marjorie Wensley of the West Country Studies Library who have helped to identify and elucidate some of the items.

Group of printed paper dolls illustrating an US Wedding, 1939.
Misc. 67–1976 Given by Miss H G Marston

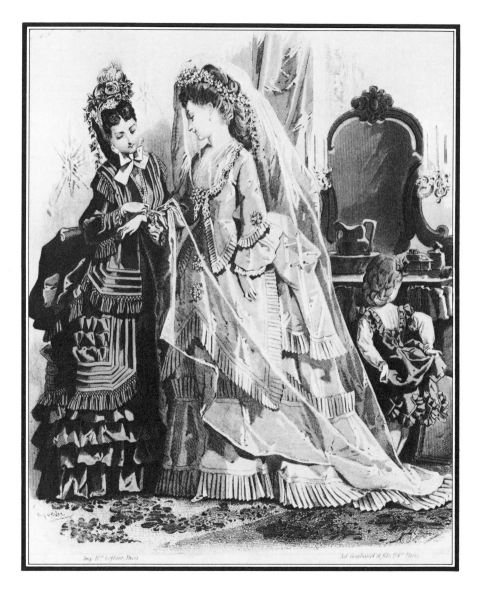

*T*HE wedding dress collection of the Victoria and Albert Museum is witness to the tastes and sentiments of two and a half centuries of British womanhood. Even though etiquette books might moralise about ostentation, recommend a pure simplicity, and warn against the 'choice of white elephants which the white satin costumes of other years have so often proved' (M M *How to dress and what to wear*, Methuen, 1903), on the whole their advice was disregarded except by the poorest or the most thrifty. Brides wanted a special dress, usually elaborate and above all fashionable, for the crowning day of their girlhood – their wedding day. Since this was a prestige occasion for the whole family it was an ambition which required, and usually obtained, full support from the parental pocket book.

For the museum, the result is a splendid series of gala dresses as important aesthetically as they are historically. The formal 'white' wedding gown is, by definition, confined to a limited range of colour and depends on contrasts of texture and nuances of tone for its decorative effect, devices deployed with a bravura which still has something to teach the designers of today. In addition, since the date, the names and the status of the wearers are quite often known, the dresses become a social as well as a sartorial record.

Most of them are in their original condition, a tribute to the care with which they were kept, for it is only within recent years that they have been regarded as dresses for a day. In earlier times convention dictated their wear for formal social occasions in the first few months after the wedding and according to the rank of the wearer, they were also worn for presentation at court after marriage. Considerable ingenuity was devoted to achieving these transitions with minimum alteration.

The acceptance of virgin white as the most usual colour for formal wedding dress coincided with the age of sentiment. White has been a

Fashion plate of 1872 E.2221–1888

conventional, if not an exclusive choice since mediaeval times, but during the eighteenth century it became increasingly popular, quite frequently mixed or trimmed with silver. Since a marriage ceremony could be a relatively private family occasion, some wedding dresses were neither specialised nor particularly elaborate, and the choice of style was governed chiefly by the time of day at which the ceremony took place and by the rank of the wearer. There was a slight preference for the more formal styles; the 'mantua', characterised by its draped train, was popular in the first half of the century and the 'sack with flowing back pleats' in the second half.

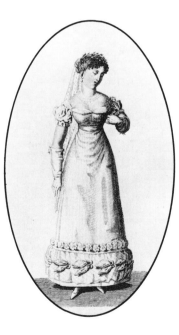

Fashion plate, circa 1820
E.2797 1888

A.E.MARTY.

The first dress associated with a wedding in the Victoria and Albert Museum collection, and incidentally the earliest in any British collection, is that of Isabella Courtenay, fifth daughter of Sir William Courtenay, second Baronet and *de jure* fifth Earl of Devon, who married the physician Dr John Andrew in Exeter Cathedral on 14 May 1744. It is a cream silk mantua with a petticoat, embroidered with colourful spring flower garlands rising from a silver rococo border of swags and shells, and requiring the support of side hoops which were five feet wide. In style it is as much a court dress as it is a wedding dress and a significant illustration of the state and standards of the English nobility in the reign of George II.

Mantua of cream silk embroidered in multi-coloured silks and silver thread, English dated 1744. It is associated with the wedding of Isabella Courtenay with Dr John Andrew in Exeter Cathedral on 14th May 1744.
T.260$^{&a}$–1969

Much less extravagant and extreme was the 'Mrs Powell wedding suit 1761', a figured white silk sack with lace tucker and wired and stiffened cap, a miniature replica of which is worn by a doll thus labelled in an eighteenth century hand, one of a series which is said to have been dressed by the bride herself.

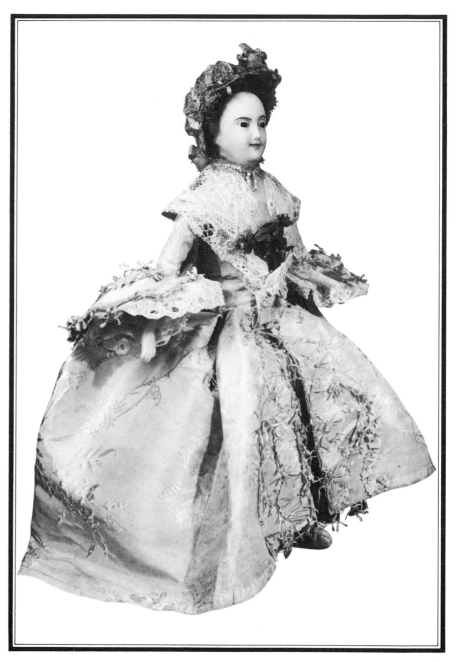

Wax doll dressed as a bride.
English, dated 1761.
An attached label is inscribed 'Mrs Powell Wedding Suit 1761'
W183(7) 1919 Gift of Mr H J Powell

The next two dresses date from the last quarter of the century. There is a sack of pure white satin, the wide skirt supported on a rectangular side hoop almost as wide as that of Isabella Courtenay, but by this time an archaic survival and worn only for formal occasions. It is trimmed with curving bands and ruched puffs still on their original cotton padding. It was very well made, perhaps by a French dressmaker, for there is something slightly un-English in the adjustment lacing inside the back of the body, in the subtly curving body and in the precise adjustment of the pleats at the hips. Its style dates to the mid 1770s but neither the maker nor the first owner of the dress is known.

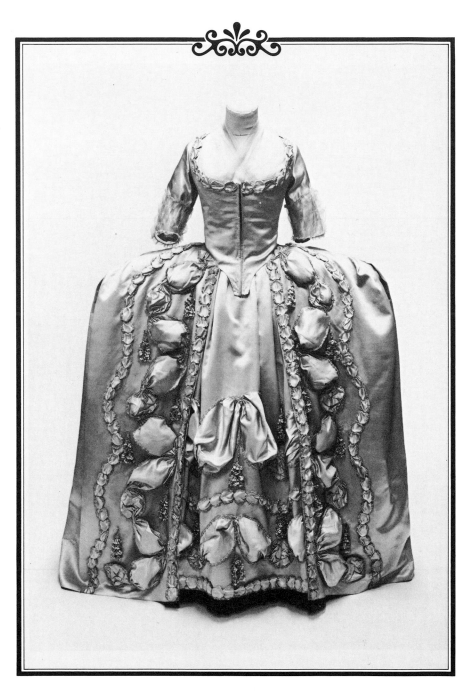

Wedding dress of white satin, a 'sack' with matching puffed and gathered trimming. English, circa 1775. T.2 ᵉᵃ–1947.

Next in date is the white and silver tissue robe, trimmed with silver, which was worn by Sarah Boddicott at her marriage to Samuel Tyssen of Felix Hall, Essex, in 1782. Another, very similar in colour and style, and dated 1783, is now in Canon Hall Barnsley, Yorkshire; it was worn by Miss Mary Winifred Spencer – Stanhope. The bodice front of Sarah Boddicott's dress was slightly altered, probably soon after the wedding – a minor modification common at a period when fashion changes were swift and an alteration easily covered with a generous kerchief. The splendid associated silver stomacher may have been handed down from a preceding generation.

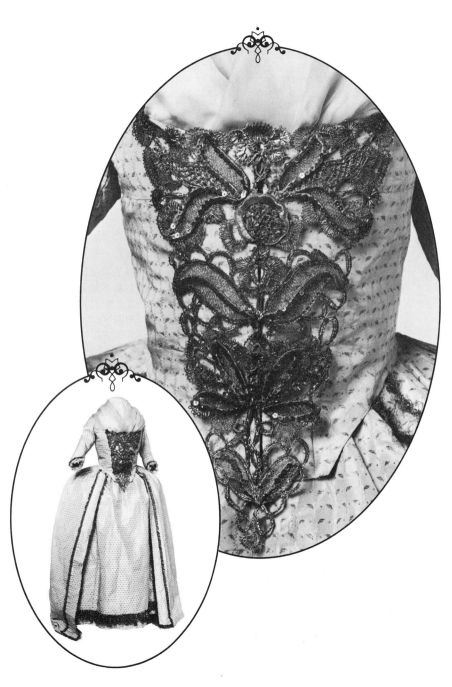

Wedding dress of white and silver tissue trimmed with silver fringe. English, dated 1782. Said to have been worn by Sara Boddicott for her marriage to Samuel Tyssen of Felix Hall, Essex. The dress which has a fitted and pleated back shows considerable signs of alteration perhaps to modify it for the styles of the 1780s. The silver braid stomacher, though for long associated with it, is more characteristic of the 1740s.
T.80[-b]–1948 Gift of Mrs R Stock

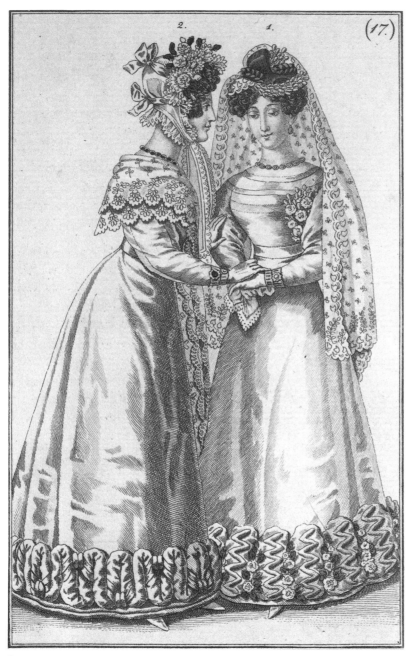

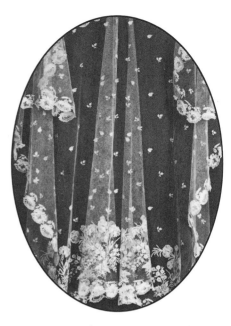

Wedding veil of 'point de gaze' with a 'hand-made reseau.'
Flemish, circa 1870.
The veil was exhibited at the Columbian Exhibition, Chicago, 1893, where it was purchased by Roxana Atwater Wentworth for her marriage to Clarence Wenthrop Bowen in 1894. Her daughter, Roxana also wore it for her marriage. Wedding lace often acquires the status of an heirloom. Associated with it is a matching cap (not shown).
T.366–1970.

Fashion plate of 1825
E.4314–1914 Gift of Sir William Ingram

The nineteenth century series of wedding dresses in the Museum's collection begins with an example of 1821. It is fairly plain with a low, square neck, puffed sleeves covered with net over-sleeves, and a hem emphasised by applied trimming; this dress is in no way dissimilar to the many plain dinner dresses of the time.

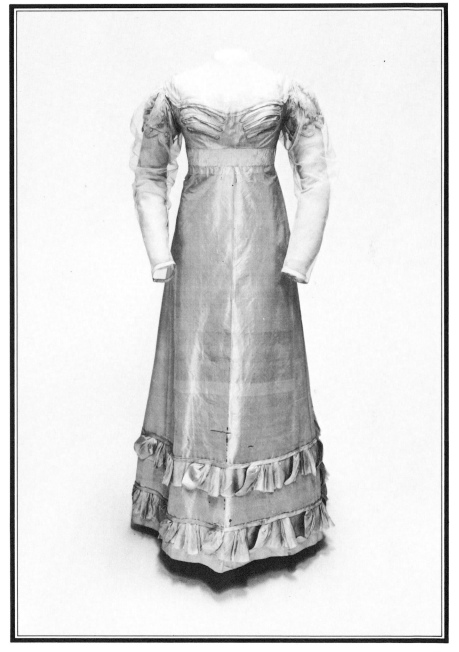

Wedding dress of white silk trimmed with satin application and having net sleeves. English, dated 1821.
T.127–1929 Gift of the Misses F & M Mold

The next, dated 1828, and in the
height of contemporary taste for
evening costume, is said to have
been purchased in Paris for the
marriage of the Hon. Frances
Barrington to the Earl of Dartmouth.
It is of white silk gauze, heavily
embroidered in silver strip; the large
puffed sleeves are veiled in silk
'blond' lace.

With the dress are the wedding
garters: their retention is perhaps a
polite commemoration of earlier,
more bucolic days when it was
customary to throw the bride's
garters to the wedding guests. They
are an attractive pair, made from
white satin and elasticated with a
series of tightly coiled strings
threaded through the fabric. They are
embroidered with silver flowers
having scarlet centres, and their
clasps are silvered. The original
shoes were also retained.

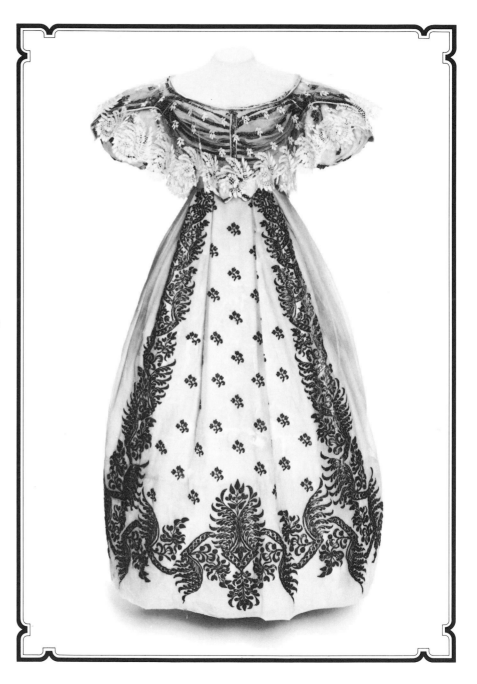

Wedding dress of white crepe embroidered
with silver strip and trimmed with
'blond' lace. French, dated 1828.
It is associated with the marriage of the
Hon. Frances Barrington to the Earl of
Dartmouth. It was worn with the garters
of white silk embroidered with silver and
the white shoes trimmed with self-
coloured embroidery.
T.9^{a-d}–1929 Gift of the Hon. Mrs Brooke

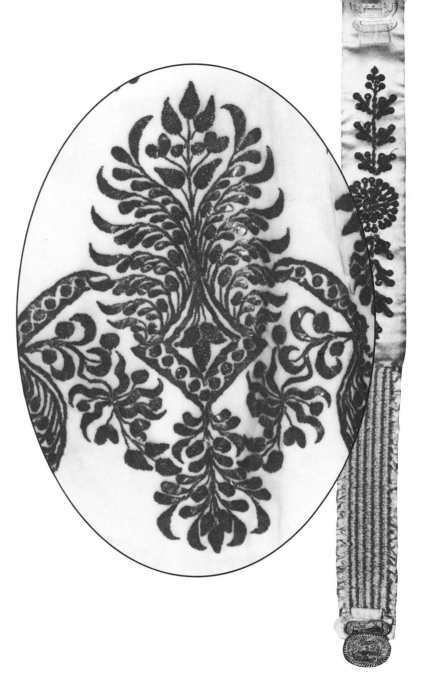

Veil of Brussels bobbin lace with 'vrai
drochel' ground Flemish, circa 1830.
Veils of this kind were sometimes used as
a wedding head-dress
T.120–1967 Gift of Lt. Col. Eric Penn

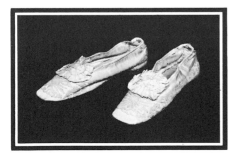

Indeed foot and legwear, such as shoes, stockings and garters – also corsets – all items where folklore tradition is re-inforced by symbolic significance, quite often accompany dresses into the collection, thus enriching our series of dated accessories. Lace, always an expensive accessory and often a gift from the bride's family, seems to acquire the tradition of an heirloom and tends to come to us detached from the wedding outfit that it once accompanied. It is in the early nineteenth century, when coiffure was elaborate, that the lace veil and the orange blossom wreath became normal fashionable styles of headgear, considered appropriate for weddings because of their vague classical and biblical associations. Fashion plates show a variety of arrangements.

Fashion plate of 1836
E.22396 (341) 1957 Gift of the House of Worth

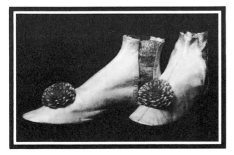

Fan of a design which is often associated with a wedding French, circa 1770.
It has a silk leaf, painted in gouache with the garlanding of Cupid's altar. The sticks and guard are of carved and gilt mother of pearl.
T.765–1972 Bequeathed by Mrs C R Thornett

Boots made from cream coloured kid trimmed with matching silk rosettes and having elastic gussets.
English dated 1865.
They were worn by Mrs Bright at her wedding with the wedding dress shown and given to the museum with it.
T.43 1974 Gift of Miss H G Bright

A pelisse robe of the early 1830s, made from white muslin. embroidered in white with a floral design is as restrained as the Hon. Frances Barrington's dress is opulent. Its sleeves too are very large but set low at the shoulder. The transition from full to narrow sleeve is well illustrated by a dress of 1841, made from a lustrous figured satin, with the long pointed waist and gently full floor-length skirt typical of the decade. The neckline is low, a feature which disturbed some contemporaries, with its suggestion not of a church, but of the ballroom, the profane rather than the sacred! It is a conscious and romantic attempt to recall the styles of the eighteenth century.

Wedding dress of white muslin embroidered in white and mounted over matching satin. English, circa 1830–5. The collar of approximately the same date is not an integral part of the outfit. T.63–1973 Gift of Miss Gaster

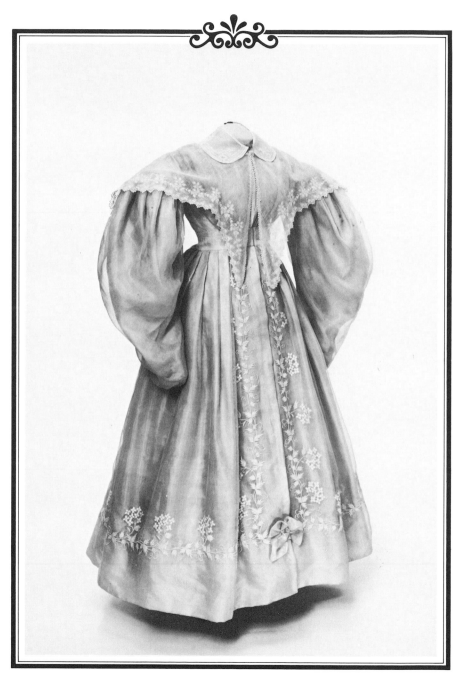

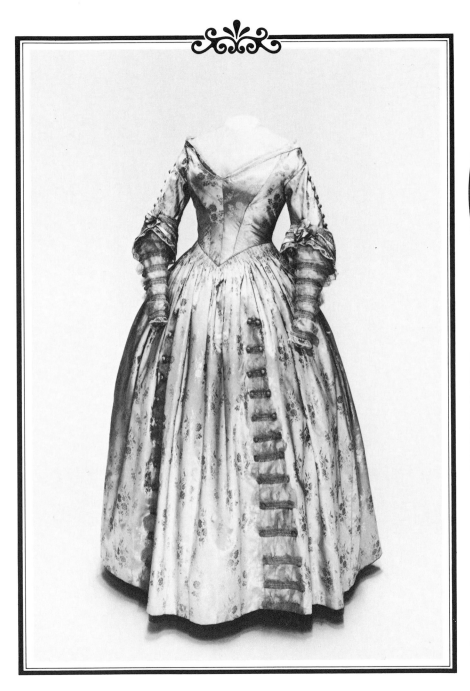

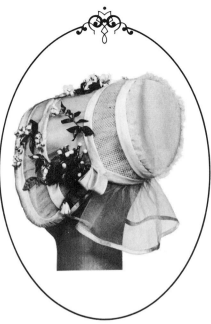

Wedding bonnet of tulle trimmed with orange blossom, English dated 1845. Worn by the donor's mother at her wedding. Bonnets were sometimes preferred to wreaths at this period, especially if a high cut day costume was worn.
T.69–1929 Gift of Miss H Blanche Buckley

Wedding dress of cream figured satin trimmed with puffs of net held by satin rouleaux and worked buttons. English, dated 1841.
T.17–1920 Gift of Miss H Bousfield.

There is a feeling of restless aggrandisement about the styles of the middle nineteenth century which coincides with the stirrings of the movement towards women's emancipation; and there is an ostentation which reflects the significance attached to the wedding ceremony. An important feature is the extreme fullness of the skirt, a feature stressed and emphasised by the popularity of flounced trimming.

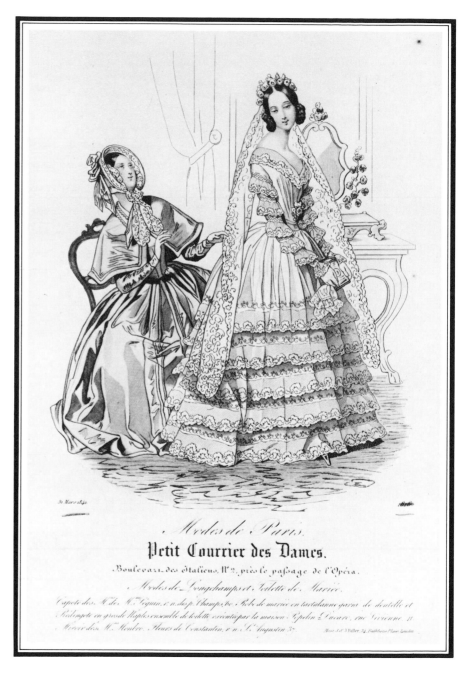

Modes de Paris.

Petit Courrier des Dames.

Boulevart des Italiens, N.2, près le passage de l'Opéra.

Modes de Longchamps et Toilette de Mariée.

Fashion plate of 1843
E.4308–1914 Gift of Sir William Ingram

16

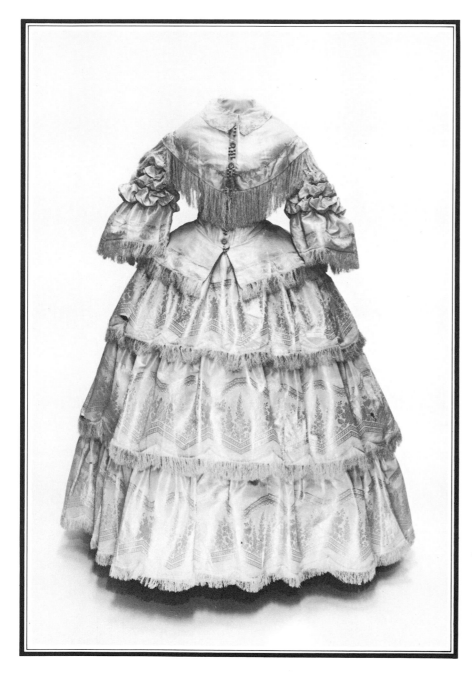

The dress of 1857 is made from an unusually fine ivory silk figured 'en disposition'; the pattern is woven in the piece and the flounces are cut to correspond. The dress is provided with a matching low cut bodice so that it can also be worn as an evening costume. The skirt is lined and faced with buckram for stiffness and is equipped with an effective set of cord pulls so that it can be raised for ease of movement. It is possible that with this amount of reinforcement, no artificial crinoline was necessary.

Wedding dress of ivory silk with a figured directionally woven pattern. English, dated 1857.
It was worn by Margaret Lang for her marriage to Henry Scott in 1857. The wreath and evening bodice associated with the dress are not shown.
T.10$^{&a}$–1970 Gift of the Misses I & N Turner

But this could hardly have been the case with the dress dated 1865, whose abundant folds of satin need all the support a wire cage could give. This dress is lavishly and expensively trimmed with Honiton lace, which was popularised by Queen Victoria who had chosen it to trim her own wedding dress in 1840.

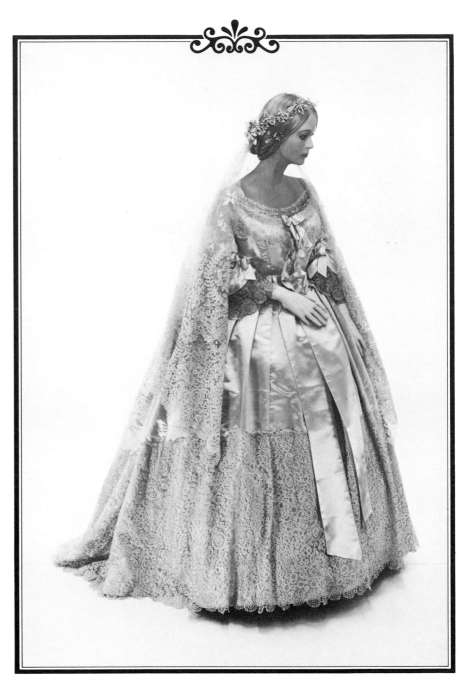

Wedding dress of ivory satin trimmed with Honiton lace, and with matching veil. English, dated 1865.
It was worn by Mrs Bright for her marriage in St James', Piccadilly on 16th February 1865.
T.43$^{&a}$–1947 Bequest of Miss H G Bright

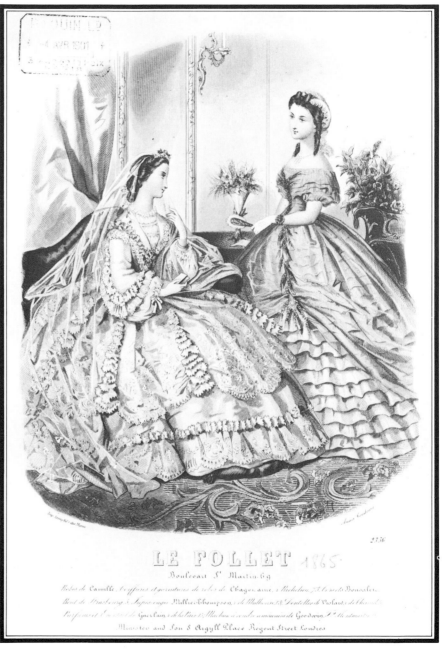

*Fashion plate of 1865
E.21811–1957 Gift of the House of
Worth*

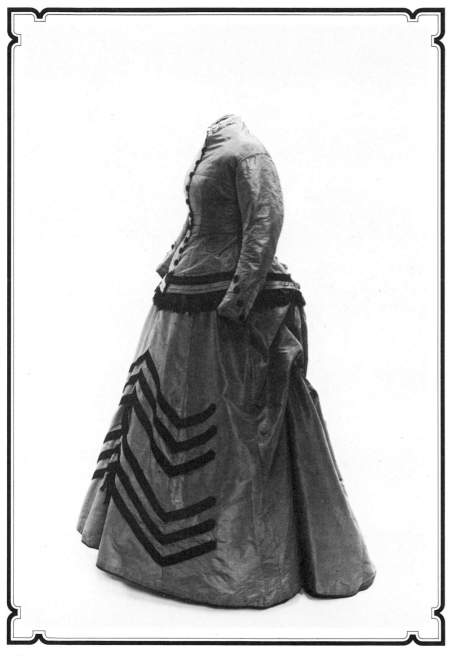

In the second half of the 1860s fashion returned briefly to a simple, less ample line, with a neat high-waisted body, skirts smooth at the hips, and a silhouette that was angular rather than rounded. A dress in this style dated 1869 is unaltered in cut, though some of the trimming is reconstructed. It is a rare example, for dresses of this period were often made over in the 1870s: their comparatively straightforward basic structure was easily overlaid with draping and trimming, which could be speedily executed on the sewing machine, then coming into general use. However, despite its availability, by no means all dresses of this period were made on the sewing machine. It was a tool which many home dressmakers, especially the

Day dress of purple and pale blue shot silk trimmed with black and silver braid and black machine made lace. English, dated 1870. It was worn by Mary Anne Bennett for her marriage to Charles Joseph Bardwell in St Mary's, Stratford at Bow on 22nd December 1870. The bride, from an artisan family, had chosen a day dress for its greater future usefulness. The alterations, carried out with considerable skill, include slight enlargement of the seams and new trimmings and internal skirt draping tapes to prolong its semi-fashionable existence at least until the 1880s. T.256&a–1979 Gift of Mrs May Parsons

thrifty and careful, preferred not to use because it made subsequent alteration and remodelling noticeable and more difficult. It was, for instance eschewed by Mary Anne Bennett, one of the few working class brides whose dresses survive in museum collections. She wore an attractive purple and blue shot silk dress for her marriage to Charles Joseph Bardwell, a bricklayer, in the Parish Church of St Mary at Bow, in 1870. Like most girls of her class she chose a coloured gown because of its general usefulness. Its condition is so good and the workmanship and handstitching so fine that it is only on close examination that the alteration she found necessary to adapt it to the changing styles of the 1870s becomes apparent. The similarities and differences between her dress and a conventional wedding dress can be illustrated by comparing it with a dress of 1872–4. It is made from a light striped silk gauze, one of the many sheer fabrics fashionable at the time, the white of the silk set off by the cream of the heavy machine-made lace trimming, and is typical of the period in having a looped overdress and peplum.

Wedding dress of white striped silk gauze trimmed with cream machine made lace. English, circa 1872.
It is associated with a wedding in the Seebohm family.
T.68ᵃ ᵉ ᵇ–1962 Gift of Miss Felicity Ashbee

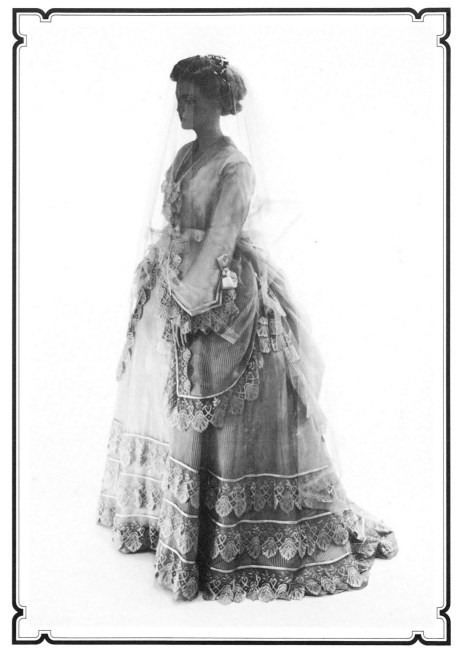

The ingenuity lavished on the back of the skirt was endless. The dress of circa 1876 is an example of art concealing art, for it has a 'tyed back': an intricate series of internal tapes ensures the very slightly draped but ruthlessly sheath-like line. The French wedding dress of 1880, made by Worth and worn by a daughter of Isaac Merritt Singer, the millionaire sewing machine pioneer, shows the style of the 1880s at its best and most elaborate: it is the earliest 'haute couture' wedding dress in the museum. The bead embroidery is typical of the work of the house. It is interesting to compare it with one of the last to be made by the London branch of the firm in 1961, a double tunic of white satin again enhanced by elaborate embroidery.

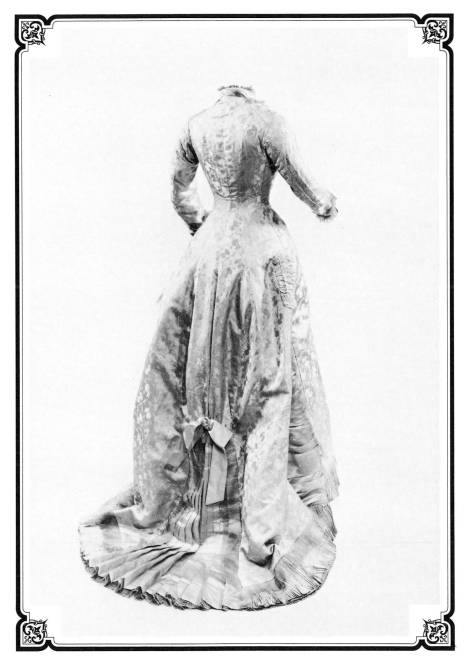

Wedding dress of ivory figured silk trimmed with matching tulle.
English (Mrs Heron), circa 1876
T.89–1959 Gift of the London Academy of Music and Dramatic Art

22

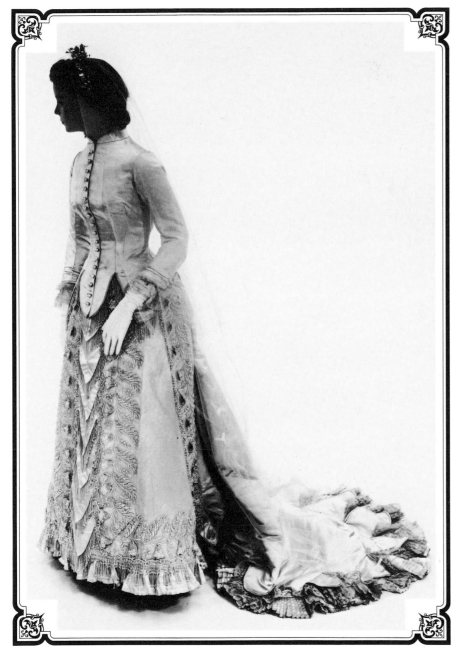

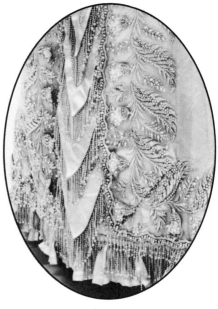

Wedding dress of white satin trimmed with pearl bead embroidery in a design of bell-like flowers and fringes. French (Worth), dated 1880. Worn by the grandmother of the donor for her marriage at St George's Hanover Square on 19th February 1880.
The dress is shown without its associated cream velvet train.
T.62&a–1976 Gift of Mrs G T Morton

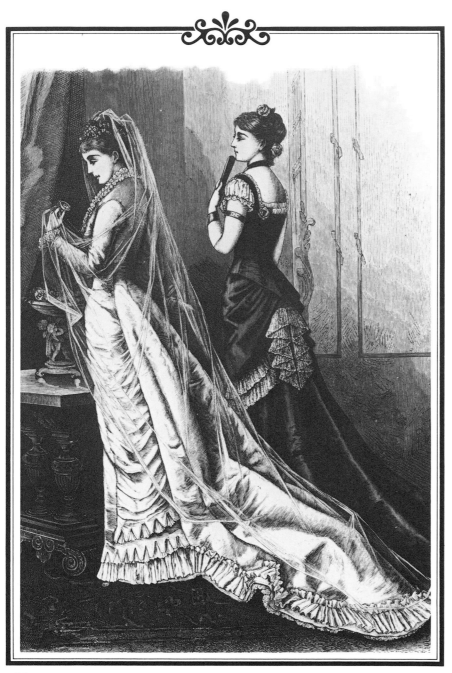

The fashionable line of the 1880s was as restrictive as it was elegant, especially when the encumbrance of a train was added; so, in the middle 1880s. the bustle was reintroduced in the form of a support or pad placed more or less horizontally in the small of the back so as to support the additional weight of material. With such a foundation, a skirt could become a complex series of drapes, swags and pleats arranged with an elaborate casual asymmetry.

Bored with the skirt, fashionable attention turned to the sleeves, plain and very tight in the 1880s. Their first modification was at the instigation of the dress reformers, who considered them unaesthetic and potentially injurious. The smocking and soft puffs of the sleeves of a white satin dress of the early 1880s are very typical of the sort of change they advocated, though the remainder, the draped bustle-supported, trained overskirt, is conventional enough. It also has a long, shapely 'cuirasse' bodice, another fashionable feature which the dress reformers found dangerously restrictive, though here the long curving lines gently but effectively both conceal and distract from the sort of skirt-waist rearrangement which often accompanied pregnancy.

Fashion plate of 1879, E 214-1951

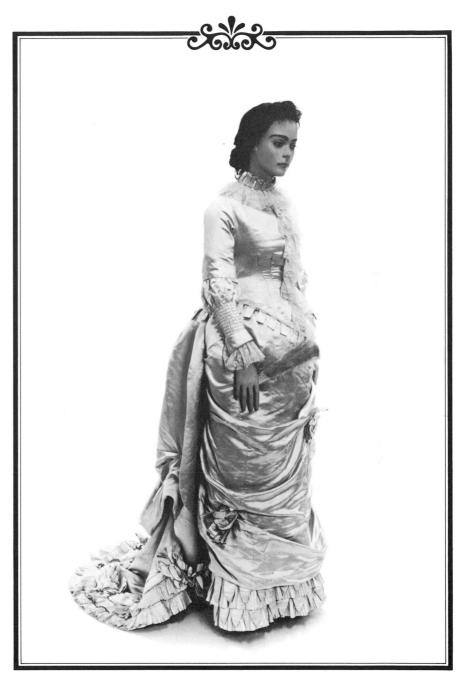

Corset of white satin.
English (Izod's Patent moulded corset) dated 1887. It was in the trousseau of the donor's mother who is said to have worn it for her wedding. Corsets with this moulded line were introduced in the late 1870's. The 'spoon'busk' was said to equalise the pressure on the stomach.
T.265–1960 Gift of Miss Benjamin
Wedding dress of white satin, smock gathered and trimmed with matching rosettes. English (Harris & Toms), circa 1882.
The dress is photographed as it would have been worn for formal dinners during the first few months of the marriage, withouts its orange blossom trimming. The skirt waist and bodice seams have been let out during its period of use. The fan, originally associated with the dress, is marked with the monogram 'I' and has an applied white feather mount and bone sticks.
T.1&a&b–1968 Gift of Mrs G M Worrall

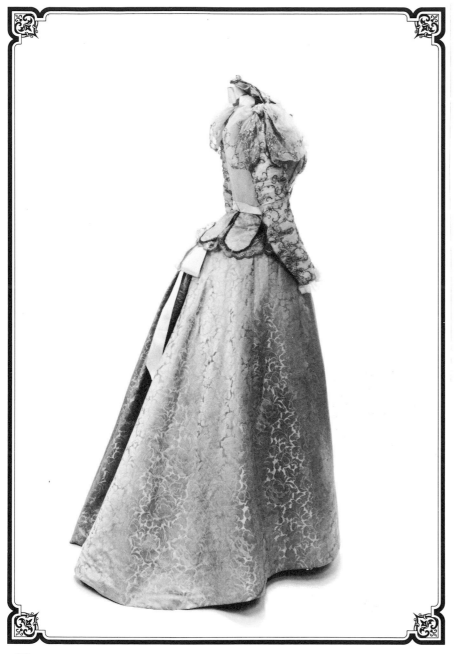

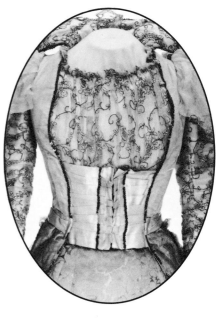

Wedding dress of cream velvet, figured silk and embroidered silk lisse. English (Madame Bertinet), dated 1887. It was worn by Evelyn Wood for her marriage to Lawrence Harley at Alton Church, Hants, on 4th December 1887. T.7&a–1971 Gift of Miss E A Harley

Illustration of a late nineteenth century bride, showing the characteristic elegant shape.

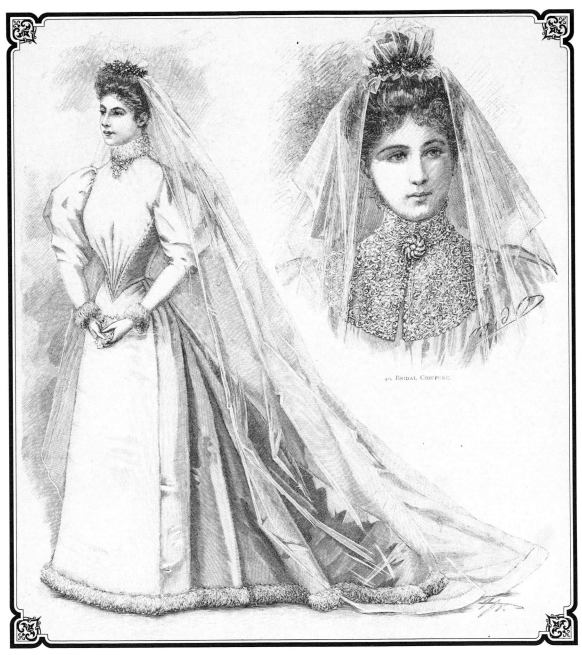

40, Bridal Coiffure.

The dress dated 1887 is very advanced for its time. Its skirt is relatively plain but its shoulders are emphasised with epaulettes of embroidered net. It has a somewhat Tudor look.

A return to styles of the sixteenth century is even more emphatically demonstrated by the dress of 1895, worn by an American heiress who married into the English aristocracy. Purchased in New York, it is probably a copy of a French couture model. It has full gathered sleeves, and the hourglass line of the figure is emphasised by the soft gleam of bead embroidery. By contrast we also have the simple grey day outfit that a bride in half mourning for her mother purchased at Mourning Peter Robinsons in 1894.

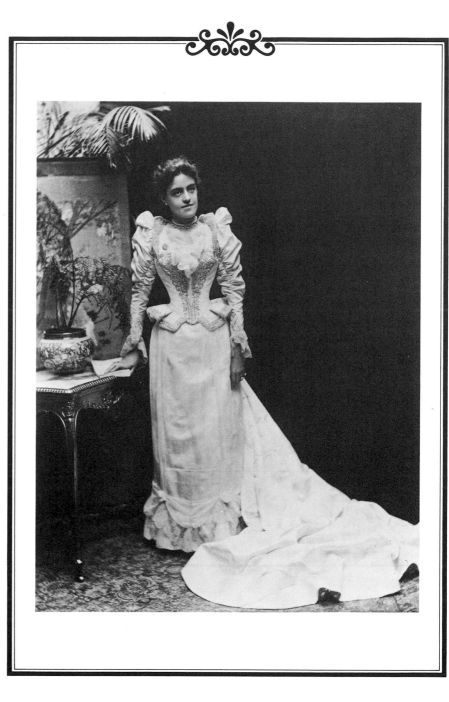

Photograph of Cara Leland Huttlesdon Rogers in the dress she wore for her marriage to Urban Hanlon Broughton on 12th November 1895. The dress, made by Stern Bros., New York, is in the museum collections, the gift of Lord Fairhaven. It is made from cream corded silk and trimmed with pastes and gathered silk lisse.

Photograph of a bride married in half mourning.
English, dated 1894.
The dress, which is in the museum collections, the gift of Miss J Spy, is made from grey silk trimmed with white lace.
The bride had recently lost her mother.

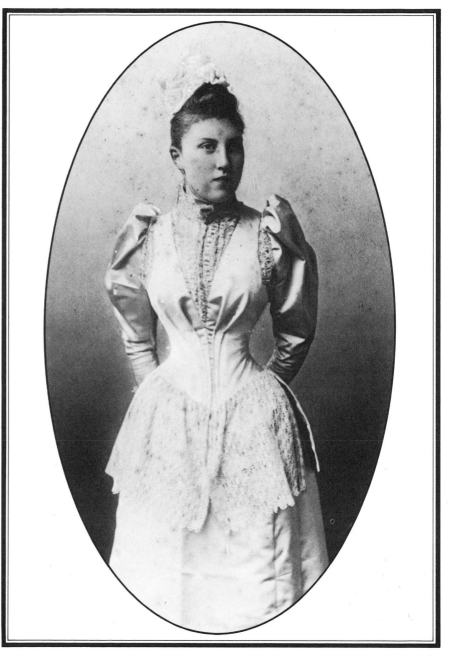

Shoes of white satin, embroidered with bronze and crystal beads. United States (Francis O'Neill) dated 1895. They were worn by Cara Leland Rogers at her marriage in 1895 and given to the museum with her wedding dress shown in plate 22.
T.276$^{b/c}$–1972 Gift of Lord Fairhaven

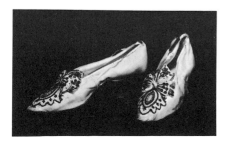

By the end of the decade, the sleeve has lost its importance and for a brief period gowns are simple, clinging to the swan-like 'S' bend silhouette. With the turn of the century, however, there is a return to more ostentatious styles and renewed interest in trimming and decoration. It coincides with the great increase in popular society journalism; weddings became public and well publicised social occasions. A dress of 1898, made for Miss Gordon by the court dressmakers, Russell and Allan, was mentioned in *The Queen*: 'the bride looked lovely in her ivory satin gown, embroidered in pearls and diamonds with chemisette and sleeves of old Duchesse point (lace) on bodice and train'. The lace described here was missing from the dress when it was received in the museum, and has been replaced with the precise equivalent, a flounce of Flemish bobbin lace purchased for a wedding in 1873. Old lace (that is, lace made by hand rather than machine) was much prized at this period and the original trimming from Miss Gordon's dress may have been detached because it was considered a family heirloom. The train is separate from the dress and attached at the shoulders. It was a version of and, as in this instance, probably served as a Court train, which had by now become a conventional wedding dress accessory. For, in the splendid setting of the grand *fin de siècle* wedding all brides were queens, at least for the day.

Wedding corset of white satin trimmed with machine made lace and orange blossom. English, dated 1905. It was made for and worn by the donor for her marriage in July 1905, and was designed to mould a slender figure into the requisite straight fronted Edwardian shape.
T.90–1928 Gift of Mrs G E Dixon

Illustrations from 'The Queen', October 1st 1898, of Miss Gordon in the dress she wore for her marriage to Mr Lawson Johnston at the church of St John the Evangelist, Stanmore in September, 1898.

The dress, made by Russell and Allan, is in the museum collections, the gift of the Hon. Hugh Lawson Johnston. It is made from ivory satin and embroidered with pastes and trimmed with chiffon. This style with the chemisette and sleeves removed would have been acceptable for presentation at Court.

In the early twentieth century the style softens and the edges are blurred with the quantity of sheer draped and pleated trimming. The more 'artistic' styles are well represented in the collection. One bride, the Hon. Alice Sibell Grosvenor, herself designed the pale blue, somewhat Italianate semi-mannerist motifs which are painted on the silk lisse of her dress. These, together with her large pseudo-classical wreath, were a predictable choice for a bride whose family had close connections with 'The Souls', the small group of aristocratic aesthetes and intellectuals whose activities did so much to enliven late Victorian society.

Fashion plate circa 1890 E 43-1918 Gift of Mrs Osbourn

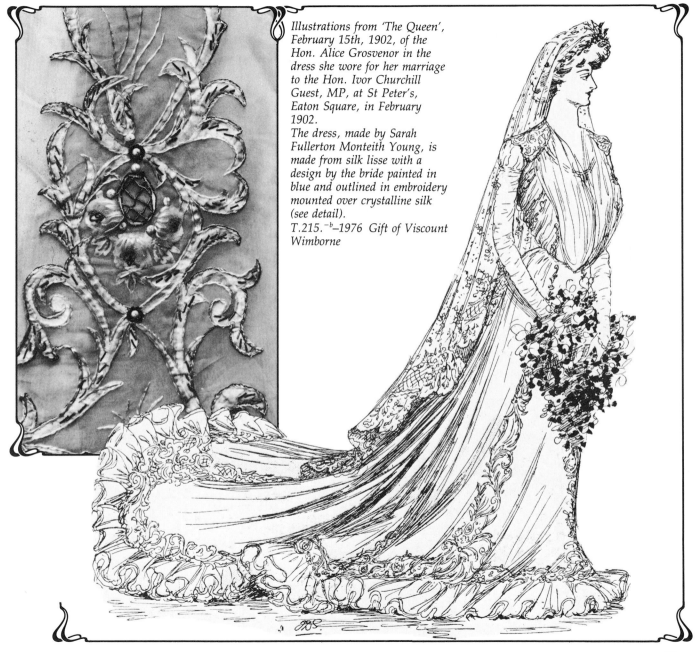

Illustrations from 'The Queen', February 15th, 1902, of the Hon. Alice Grosvenor in the dress she wore for her marriage to the Hon. Ivor Churchill Guest, MP, at St Peter's, Eaton Square, in February 1902.

The dress, made by Sarah Fullerton Monteith Young, is made from silk lisse with a design by the bride painted in blue and outlined in embroidery mounted over crystalline silk (see detail).

T.215.⁻ᵇ–1976 Gift of Viscount Wimborne

A Liberty wedding dress of 1906
affects the mediaeval mode also
popular with those of artistic tastes.
The modified Celtic motif of the
embroidery, in a style developed by
Anne Macbeth, contrasts with the
swooping, elongated, essentially
Continental Art Nouveau scrolls
which form the basis of the
decoration on a French Dress of 1908.

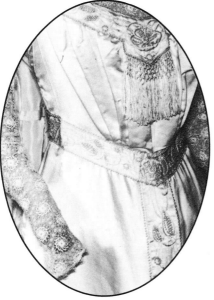

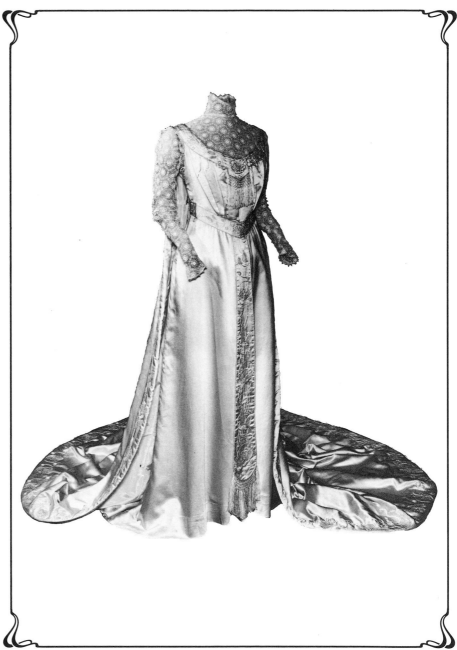

*Wedding dress of white satin with
matching embroidered decoration. English
(Liberty & Co), dated 1906.
T.463⁻ᵇ–1976 Gift of Mr Stewart Liberty*

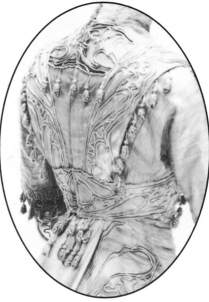

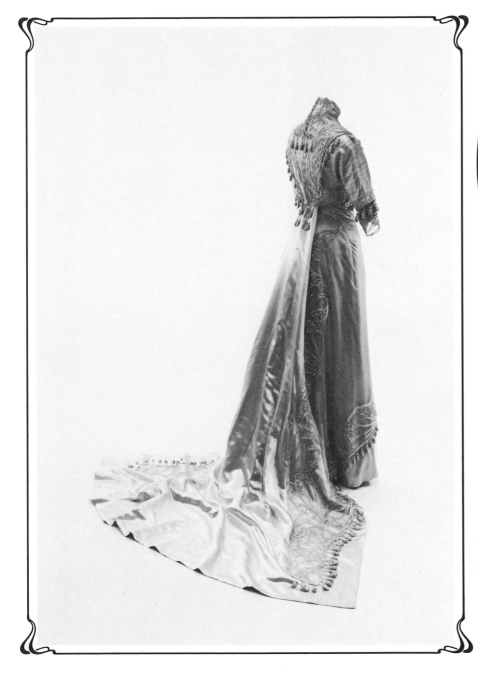

Wedding dress of ivory satin with applied decoration, French (Mme Meynier), dated 1908.
It was worn by Elaine Campbell Wakefield for her marriage to Claude Llewellyn Thorley Phillips at St George's Hanover Square on 27th July, 1908.
T.288–1971 Gift of Mrs D C Mason

Conventional high fashion is
illustrated by a dress of 1911, with its
tunic of beaded net with tasselled
fringes, draped over one of the
newly introduced tight 'hobble'
skirts. It makes an interesting
contrast to the simple garment worn
by a local Bethnal Green bride in
1910, which could also have been
worn as a summer 'best' dress.

*Detail of the draping of the overtunic of a
wedding dress of ivory machine-made lace
and satin trimmed with silver and crystal
beads, dated 1911.*
*The dress was worn by the Lady Dorothy
Edith Isobel Mercer Henderson Hobart
Hampden for her marriage to the Hon.
Claude Hope Morley at the parish church
of Hampden, Great Missenden, Bucks on
July 6th 1911.*
*T.154–1973 Gift of the family of Lady
Dorothy Hope Morley*

Wedding dress of ivory silk and wool trimmed with insertions of re-embroidered machine made lace.
English. Dated 1910.
Worn by Louisa Catherine Wittmann for her marriage in
St. Andrew's Parish church, Bethnal Green
Gift of Miss I K Linton

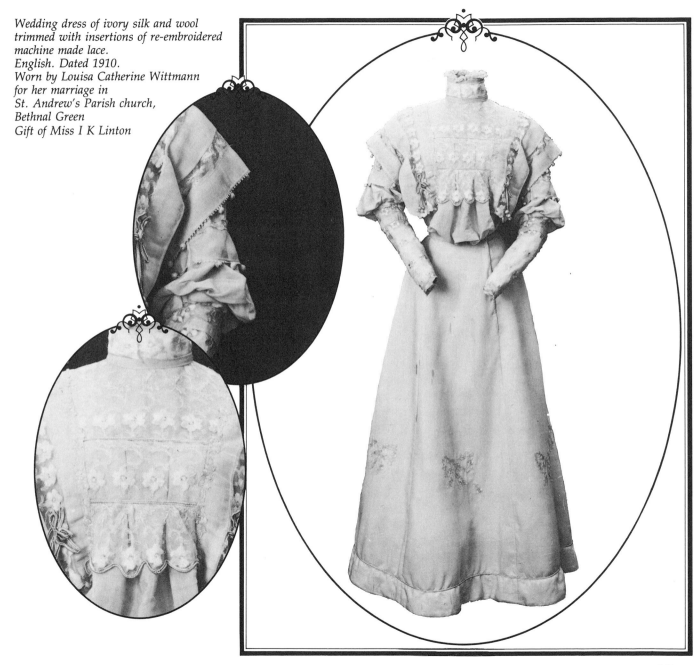

The fantasy of fashion on the eve of the First World War is illustrated by only one example in the museum collection. Dated 1914, it was worn just a month after the declaration of war. It is an early work of Ada Wolf, the East End girl who became a well known West End dressmaker, thought by some to be the equal of her more internationally famous contemporary, the couturier Lucile. The dress is elaborate, escapist and consciously picturesque; a fashionably short jewel edged tunic mounted over heavy lace, and the train lined with a ruche of pink tulle and edged with a waterfall of frills.

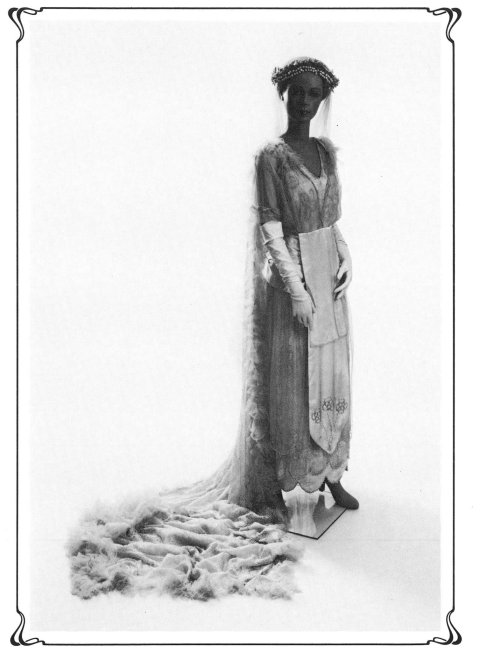

Wedding dress of ivory silk lace trimmed with tulle and edged with pastes; English (Ada Wolf), dated 1914.
It was worn by Phyllis Blaiberg for her marriage to Bertie Mayer Stone at the Bayswater Synagogue on 9th September 1914.
T.856&a–1974 Gift of Mrs B Rackow

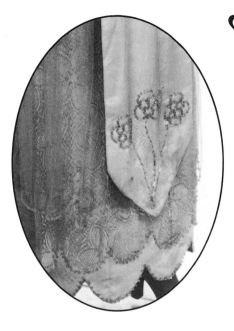

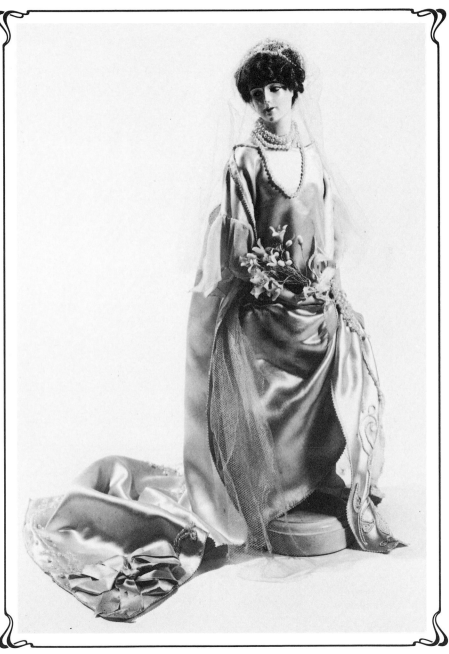

Composition doll dressed as a bride.
German/English, circa 1919.
T.275–1960 Gift of Mrs D E Fletcher

After the war the sequence of dresses
resumes with that worn by the
Princess Royal in 1922 for her
marriage to Lord Lascelles; this was
the first of the fully publicised royal
weddings held in Westminster
Abbey. The dress, made by Messrs
Reville, is in the conventional taste of
the period, softly pretty but at the
same time regal. According to *The
Queen* of 4 March 1922, it was one of
the 'triumphs of Revill (sic) . . . and
incidentally of British Achievement
throughout. The bridal robe of cloth
of silver is veiled in marquisette
embroidered in seed and baroque
pearls, silver and sparkling crystals –
a robe for a fairy princess indeed . . .
the train is embroidered with
Imperial Emblems'. It is worth noting
also that the material for the
underdress and train was woven
from real silver and Italian silk thread
by Mr T H Bunn for Warners of
Braintree in Essex, which also made
the material for Queen Victoria's
wedding train. The embroidery,
notwithstanding exotic stories that
lotus blooms had been imported
specially from India, was entirely
executed in the Reville workshops;
and in the design on the train 'rose,
shamrock and thistle . . . , the lotus
of India, the wattle of Australia, the
maple leaf of Canada, the tree fern of
New Zealand and other emblems
representing outlying portions of the
British Empire' are indeed 'happily
and lightly combined so that the
sheer beauty of the whole rather
than the symbolism of the design is
what first strikes spectators.'

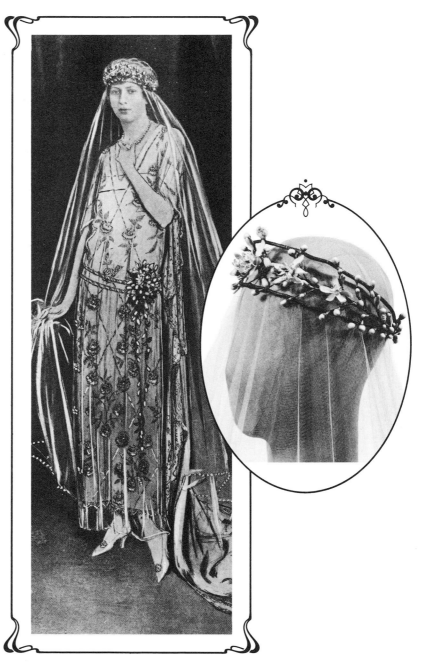

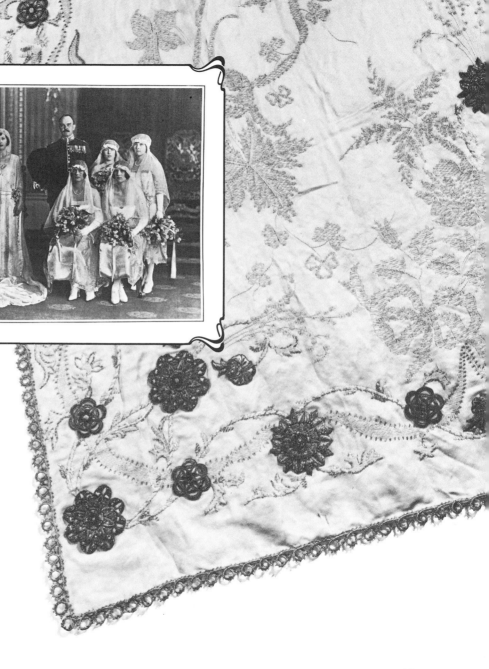

Illustration from 'The Queen' and the
'Illustrated London News' of HRH The
Princess Mary at her marriage to the
Viscount Lascelles at Westminster Abbey
on 28th February 1922. The dress, train
and head-dress designed by Messrs
Reville are in the museum collections, the
gift of the Earl of Harewood to the Beaton
Collection.

The dress is made from marquisette
embroidered in pearl and crystal beads
mounted over silver lame and with a
train of silver and ivory duchesse satin
embroidered in silver with the emblems of
Empire (see detail). The wreath is of
silver and entwined with orange blossom
(see detail).

Newspaper photograph, sketch and detail
of the fabric show how reality is modified
in reproduction.

T.355^{b/c}–1974 Gift of the Earl of
Harewood to the Beaton Collection

The fashionable line remained substantially unchanged for the first half of the 1920s, and there is in the collection another version of the pearl-embroidered tunic but worn with a pleated underdress, dated 1924. It is of fine workmanship and carries with it a charming story, for it was the wedding gift from an appreciative employer to one of his sewing girls. Another dress of the same year makes use of an alternative fashionable silhouette of the time, the *robe de style*. It is made from cloth of silver and was also designed by Ada Wolf; the influence of Paul Poiret appears in the rather daring open hanging sleeve, and there is a reminiscence of Lanvin in the full silver lace 'infanta' skirt, supported at the hips on crinoline foundation.

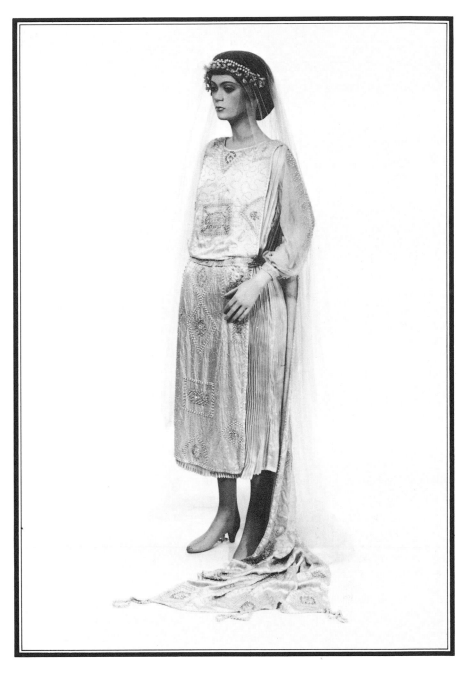

Wedding dress of ivory satin embroidered with pearl and crystal beads.
English, dated 1924.
It was worn by Mrs Gerelli on her marriage. The wreath and veil are not original.
T.252–1968 Gift of the Misses J & L Watts

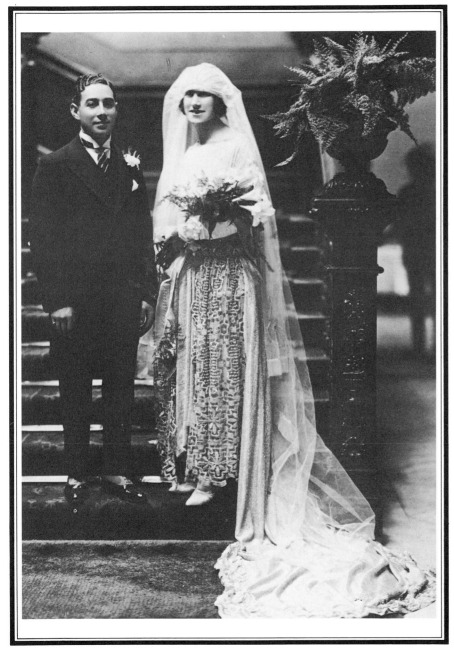

Photograph of Flora Diamond at her
marriage to Phillip Jacobs in the
Bayswater Synagogue in 1924.
The dress made from silver lace with pink
floral application on the train was
designed by Ada Wolf and was given to
the museum by Mrs A Diamond.

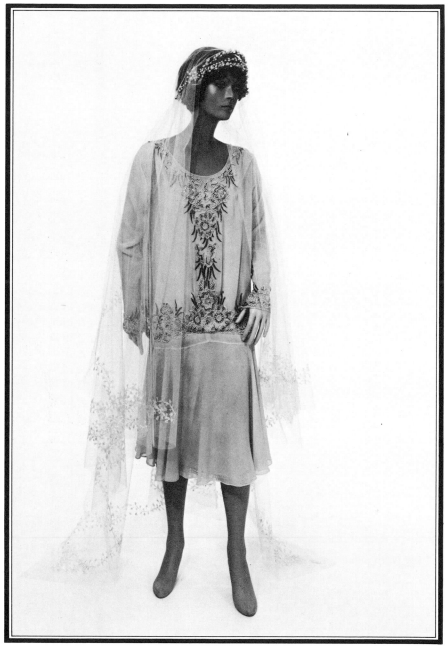

Typical of the later 1920s is a dress of 1926 by Mrs Handley-Seymour, one of the most important Court dressmakers of the 1920s and '30s. The skirt and back panel are set on the cross so as to give a graceful, light and fluid effect.

In the early 1930s there is a return to the statuesque. Skirts lengthen and the cloth is cut to mould the figure. For the first time in their history, wedding dresses show signs of diverging from the fashionable norm, and this at a time when the winds of change were blowing ever more strongly through the framework of conventional wedlock. The dresses become stereotyped and assume a sacerdotal pseudo-mediaeval simplicity; almost every bride seems a Rheinhardt nun or a Madonna looking for her Miracle. Fortunately, the dresses in the museum collection show somewhat more originality than the average. An example of 1934, worn by a Mayoress of Bethnal Green, has a very up-to-date leg of mutton sleeve and is in an unusual soft golden colour.

Wedding dress of ivory georgette embroidered with silver and crystal beads. English (Handley-Seymour), dated 1926. It was worn by Mrs E Koppenhagen, at her marriage.
T.25^{&a&b}–1973 Gift of Mrs A Kay

Bridal head-dress of artificial flowers and composition.
English (Jaks) circa 1935
During the mid 1930's, orange blossom wreaths began to be replaced by a variety of coronets.
Gift of 'Jaks'

Photograph of Freda Sylvia Benoly on her marriage to Vivian A. S. Vokes at St Matthews Parish Church, Bethnal Green on September 29th, 1934. Miss Benoly acted as Lady Mayoress to her sister The Mayor of Bethnal Green, hence the badge around her neck. The dress, which is also in the collection, the gift of Miss L D Benoly, is made from ivory yellow velvet and has 'leg-of-mutton' sleeves, and was worn with a wreath of orange blossom and a machine-made lace veil.

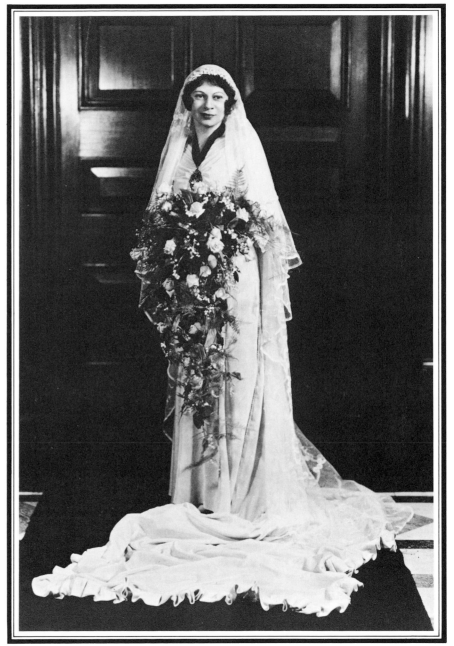

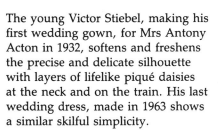

The young Victor Stiebel, making his first wedding gown, for Mrs Antony Acton in 1932, softens and freshens the precise and delicate silhouette with layers of lifelike piqué daisies at the neck and on the train. His last wedding dress, made in 1963 shows a similar skilful simplicity.

Design for a wedding dress by Victor Stiebel, 1932. The dress of white silk crepe trimmed with applied piqué flowers (see detail) was worn by Mrs Antony Acton at her marriage in 1932, together with a white iridescent sequin cap and veil designed by Lanvin (see detail). T.71/72/73–1966 Gift of Mrs Antony Acton

46

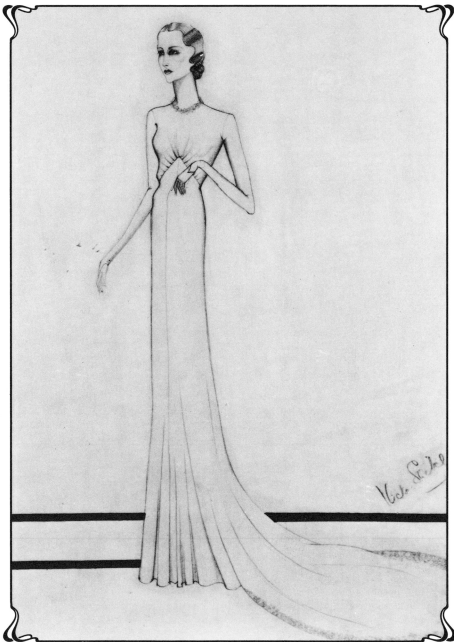

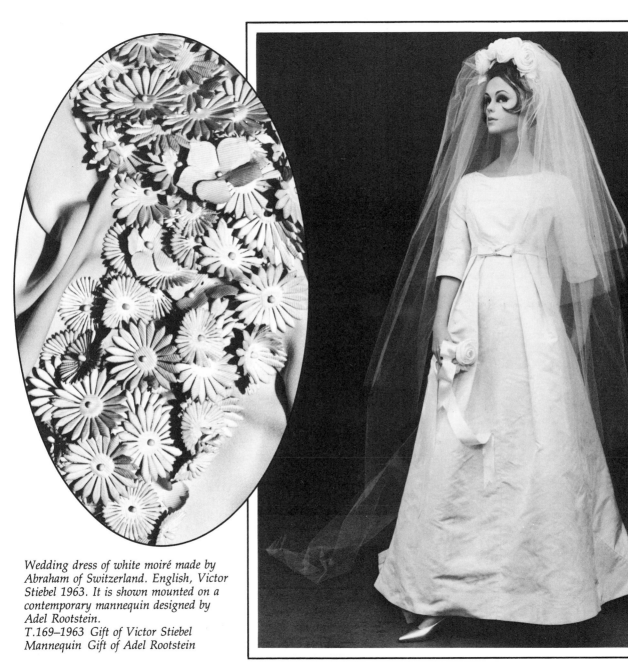

Wedding dress of white moiré made by
Abraham of Switzerland. English, Victor
Stiebel 1963. It is shown mounted on a
contemporary mannequin designed by
Adel Rootstein.
T.169–1963 Gift of Victor Stiebel
Mannequin Gift of Adel Rootstein

Star quality rather than celestial simplicity is the keynote of the altogether more extrovert dress made by the young Norman Hartnell in 1933 for the marriage of Margaret Whigham later Duchess of Argyll, whom he considered 'the outstanding beauty of all the debutantes and the one who taught the others how to dress'. For her he made a sheath of cross-cut satin, studded with pearl-embroidered transparent stars, with soft tulle borders to the wide, hem-length hanging sleeves. The 18-foot train was specially designed for the exceptionally impressive aisle of the Brompton Oratory; according to the *Daily Telegraph*, its management gave the bride 'considerable difficulty'. The Duchess recalls in her autobiography that it had taken 30 seamstresses six weeks to make the dress and that at £52 she considered it shockingly expensive. Hartnell's disciplined talent for romantic styling is also evident in the 1951 wedding dress which he made for the daughter of an old friend.

Photograph of Miss Margaret Whigham at her marriage to Mr Charles Sweeny in the Brompton Oratory, 1933.
The dress, designed by Norman Hartnell, is made from ivory satin trimmed with bead embroidered tulle insertions (see detail).
T.836–1974 Gift of Margaret, Duchess of Argyll to the Beaton Collection

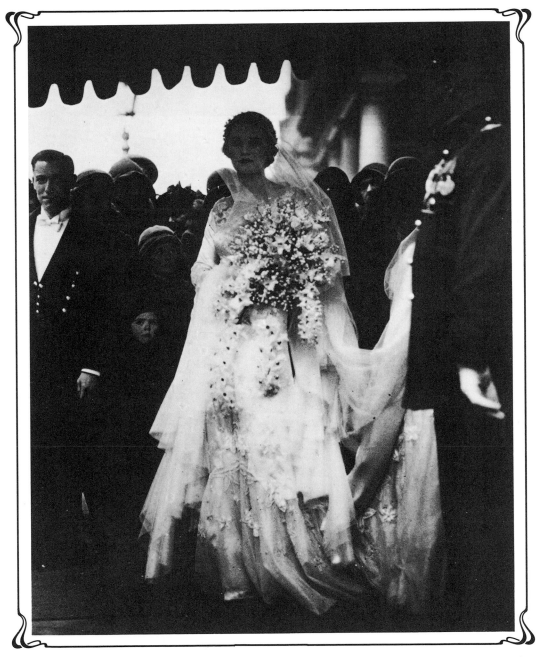

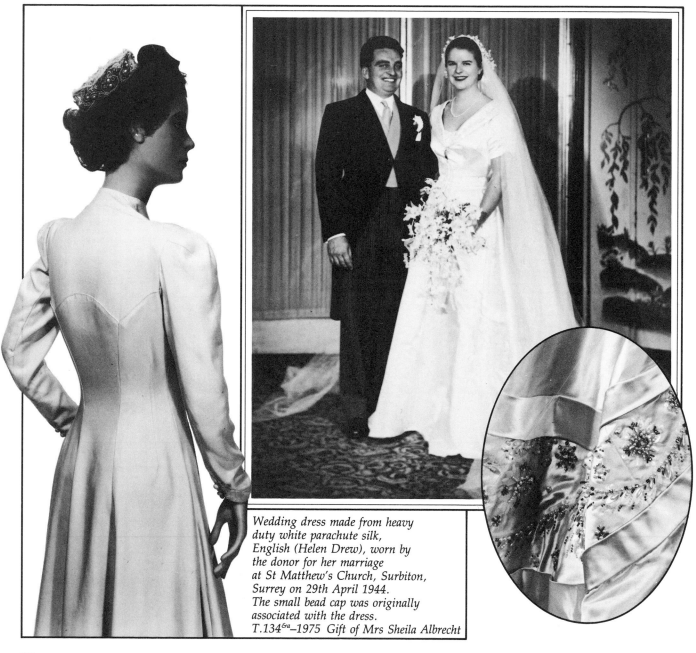

Wedding dress made from heavy
duty white parachute silk,
English (Helen Drew), worn by
the donor for her marriage
at St Matthew's Church, Surbiton,
Surrey on 29th April 1944.
The small bead cap was originally
associated with the dress.
T.134$^{&a}$–1975 Gift of Mrs Sheila Albrecht

Similar in line but vastly different in texture is the rare formal Second World War wedding dress of 1944. It is an epitome of its period; the silhouette, except for the slight broadening of the shoulders, had not changed from the pre-war years. It was made by Helen Drew, Lady Churchill's dressmaker, and the material is heavy duty parachute silk, a material not affected by wartime rationing restrictions.

In the post-war period, as prosperity replaced austerity, there is a return to the splendid gown made for a single occasion. Norman Hartnell's 1951 dress is a good example of post-war romantic New Look, with its slim waist, bouffant skirt and opulent decoration. The London Worth of 1961 semi-fitted and with a skirt in two lengths, looks forward to the shorter and more tubular styles of the 1960s, though its embroidery is traditional.

Left Photograph by Lenare of Miss Wills at her marriage to Merfyn Evans at St Mark's, North Audley Street, on 23rd July 1957
The dress, designed by Norman Hartnell, is made from ivory satin embroidered with pearl and crystal beads (see detail).
T.217&a–1972 Gift of Mrs H S Ball

Right Photograph of the donor at her marriage at St John's Wood Church, 18th November 1961, wearing a dress designed by Worth of London in pearl satin with heavy matching and crystal bead embroidery (see detail).
T.866&a–1974 Anonymous Gift

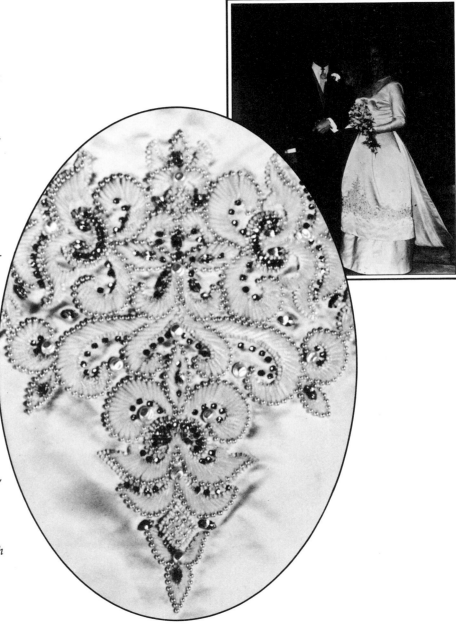

It is because of their apparent simplicity that modern wedding dresses are so demanding in the requirements that they make of the designer. A small group of sketches and samples of fabrics and embroidery from the archive of the couturier John Cavanagh illustrates the processes of thought which went into the creation of the wedding gown for the Duchess of Kent.

One of the last dresses in the series was designed by Gina Fratini in 1970. A soft, high-waisted smock in silk organza, trimmed with 19th century lace, it is typical of current wedding dress design. In conscious denial of both Unisex and Women's Lib., it is a sentimental return to the mood of an idealised past, innocent, gentle and somehow wistful. Smock-like in shape and provided with a baby-cap head-dress, it suggests one conventional contemporary attitude that marriage is traditional, old-fashioned and mainly for children.

Wedding dress of white organza trimmed with 19th century lace insertion. English (Gina Fratini), 1970.
T.194⁻ᵇ–1974 Gift of Gina Fratini to the Beaton Collection

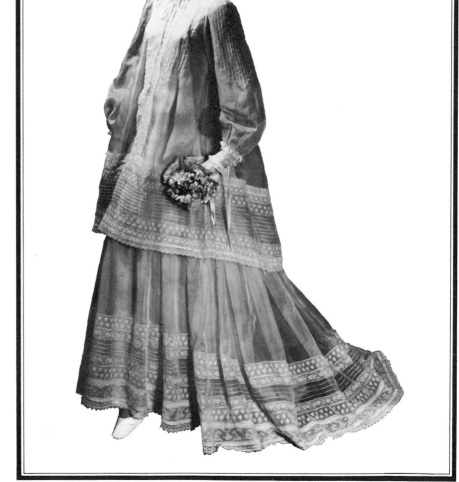

Printed in England for Her Majesty's Stationery
Office by Balding & Mansell, Wisbech

ISBN 0 11 290328 2

© *Crown copyright 1981*

First published 1981

Her Majesty's Stationery Office

Government Bookshops

49 High Holborn, London WC1V 6HB
13a Castle Street, Edinburgh EH2 3AR
41 The Hayes, Cardiff CF1 1JW
Brazennose Street, Manchester M60 8AS
Southey House, Wine Street, Bristol BS1 2BQ
258 Broad Street, Birmingham B1 2HE
80 Chichester Street, Belfast BT1 4JY

*Government publications are also available
through booksellers*

*The full range of museum publications
is displayed and sold at the
Victoria & Albert Museum
South Kensington
London SW7 2RL*